How to Draw
Babies & Children

In Simple Steps

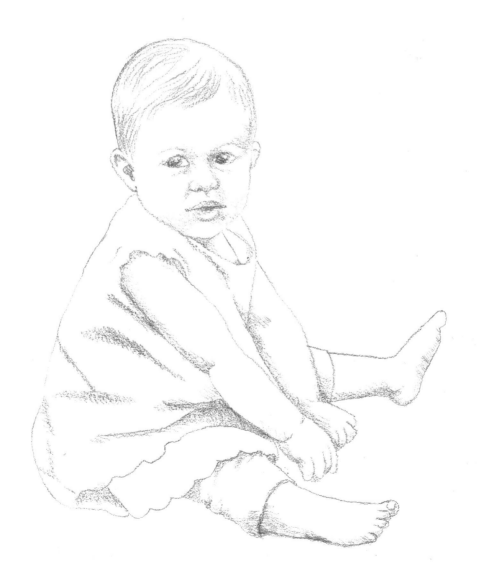

First published in Great Britain 2016

Search Press Limited
Wellwood, North Farm Road,
Tunbridge Wells, Kent TN2 3DR

Text copyright © Susie Hodge 2016

Design and illustrations copyright © Search Press Ltd. 2016

ISBN: 978-1-78221-342-0

Printed in Malaysia

Dedication

*To my own beautiful children,
Katie and Jonathan*

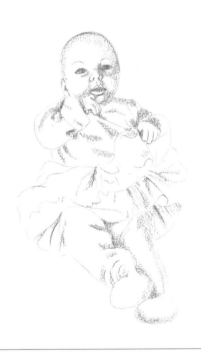

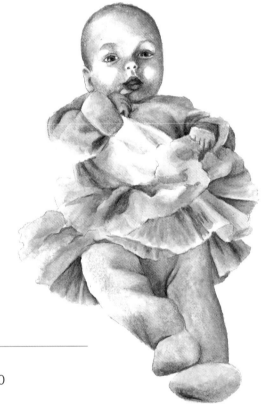

Illustrations

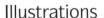

How to Draw
Babies & Children

In Simple Steps

Susie Hodge

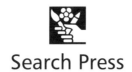

Search Press

Introduction

In this book, I use simple step-by-step drawings to capture little people, from the youngest babies to older, more active children; some sleepy, some mischievous, some contemplative or laughing – but all charming and entertaining. The best advice is to try not to think about the finished drawing as you begin and build up your drawing a stage at a time, concentrating on proportion, ratios and angles – how long is the arm from shoulder to elbow? Where are the ears in relation to the mouth?

For each step-by-step here, you will see that the first marks are made with a deep pink pencil, in the next step they are green, and then new marks are drawn in deep pink – shaping the shoulders, arms, legs, and adding some contours of clothing. The next two stages add facial features, some details of clothing and shading.

The coloured pencil method is used only to highlight each stage - there is no need for you to do this. Instead use a soft pencil, then you can erase the previous guidelines as you progress. Take your time and make sure you have drawn the correct proportions before you move on to the next step. Don't press too hard with your pencil or your initial marks will be difficult to erase.

To achieve a convincing look, don't draw every shoelace, every button or eyelash, but use a light touch and some general, overall indications, such as a print on a dress, a zip on some shorts, or a few stray strands of hair. Often it is the small, almost unfinished areas that seem to breathe life into a drawing. The final image on each page in this book is to show you what you can achieve with watercolour. Notice the areas where there is no paint – and no outlines. Less is often more, particularly on children who are best drawn with a delicate touch. If you're using watercolour, make sure your water is always clean, your brush is not too wet and you don't muddy your colours.

The simple sequences in this book are intended to make your drawings more accurate overall, and the whole process of drawing less daunting, so I hope you have a go at drawing each of the figures here. They are all fun and each presents different challenges. Once you are used to the process, try drawing some of your own pictures of children, whether from life or from photographs, using the same method. Don't become upset over mistakes, as these happen to everyone. If you follow the visual instructions in this book, you will soon start to feel more confident about your drawing skills and you will develop your own natural style. I hope that you will be delighted with your achievements and go on to draw many more babies and children.

Happy Drawing!

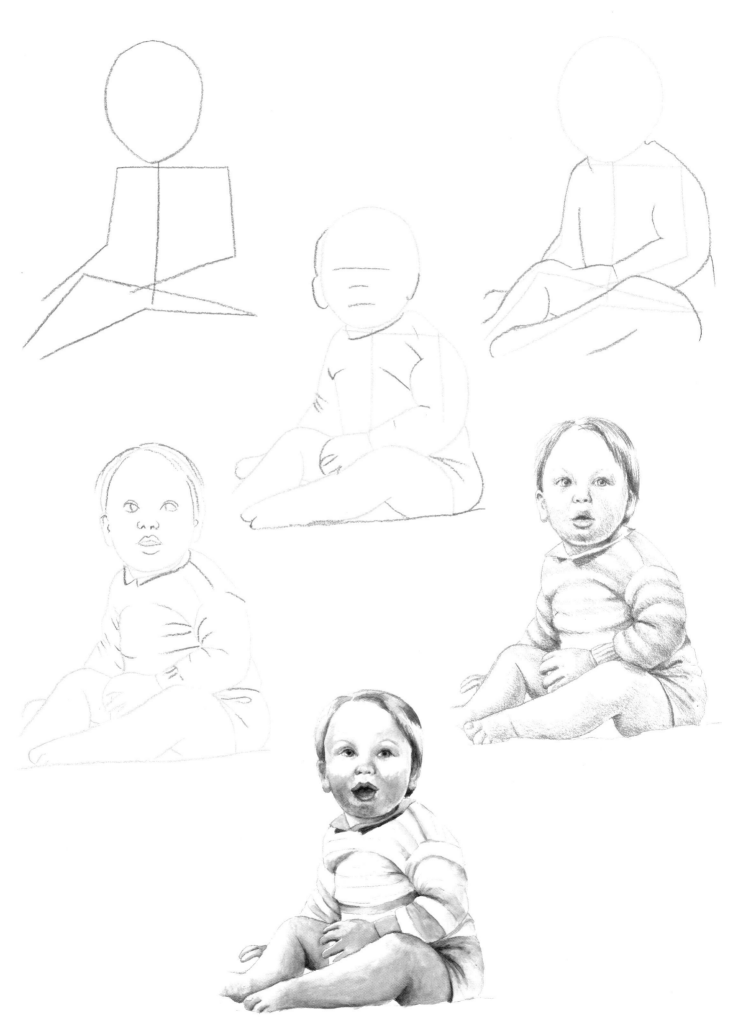

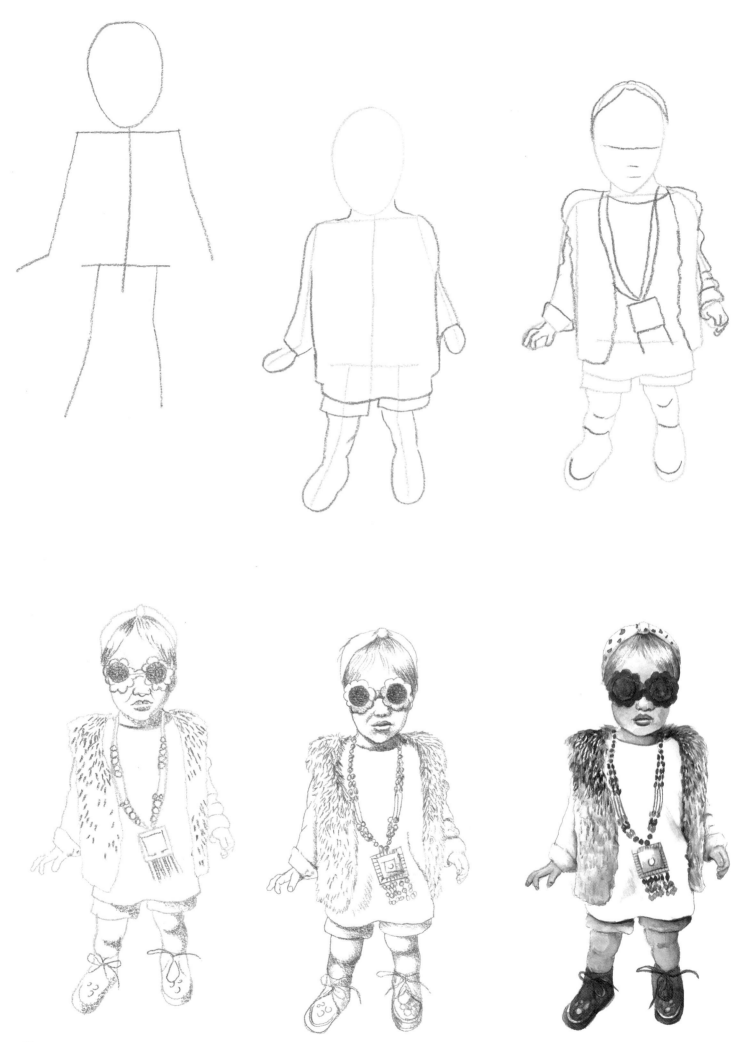

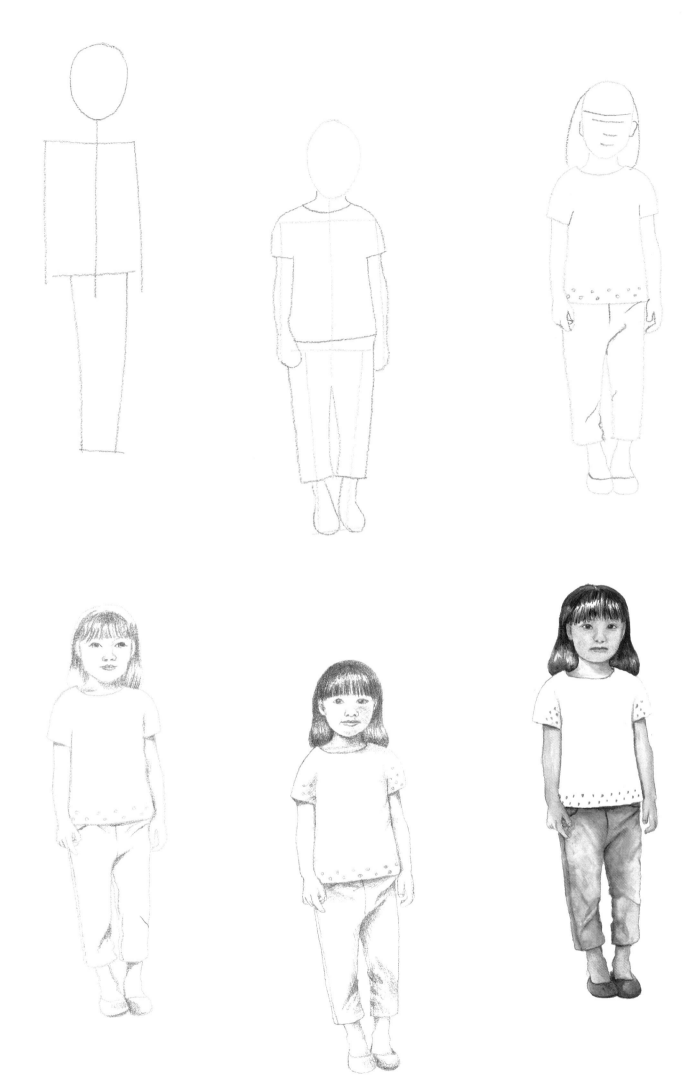

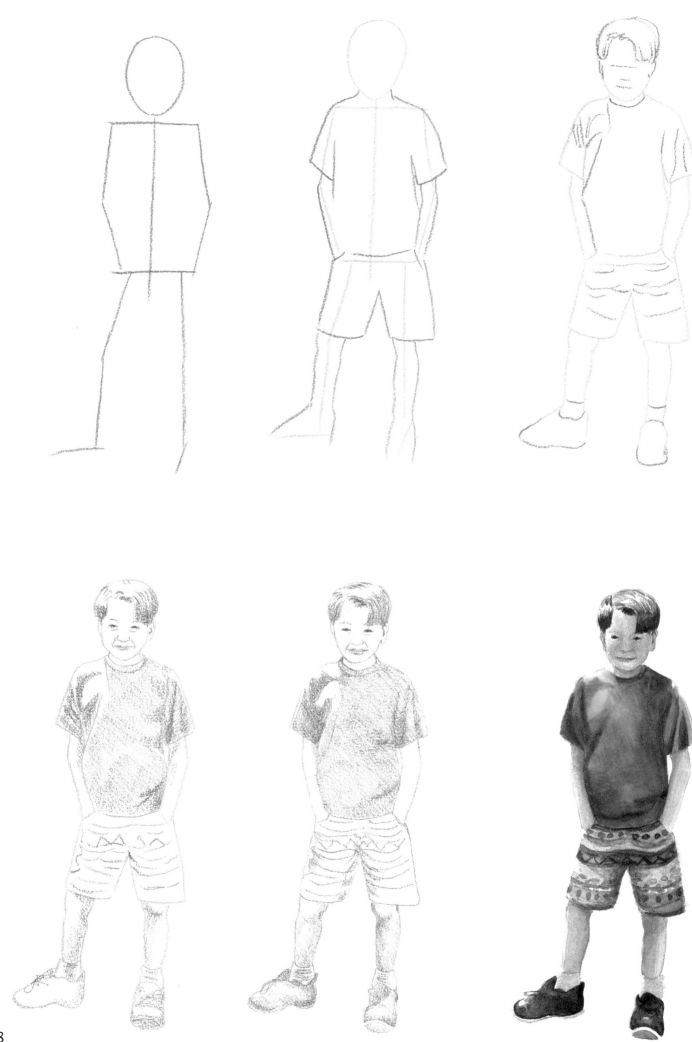

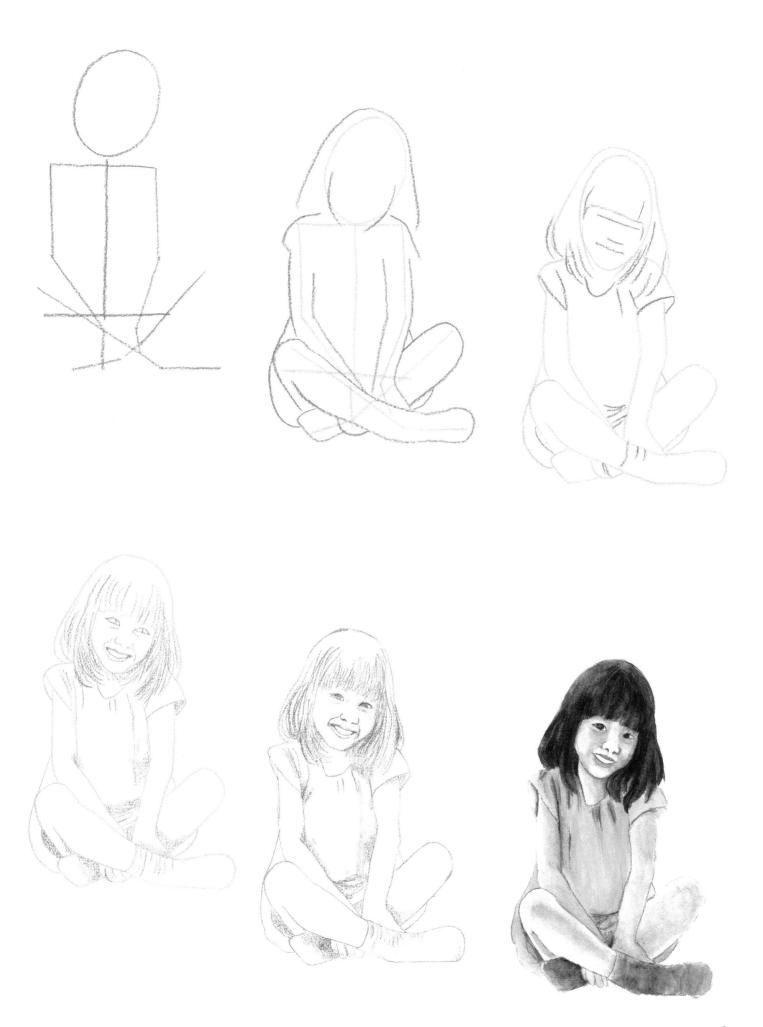

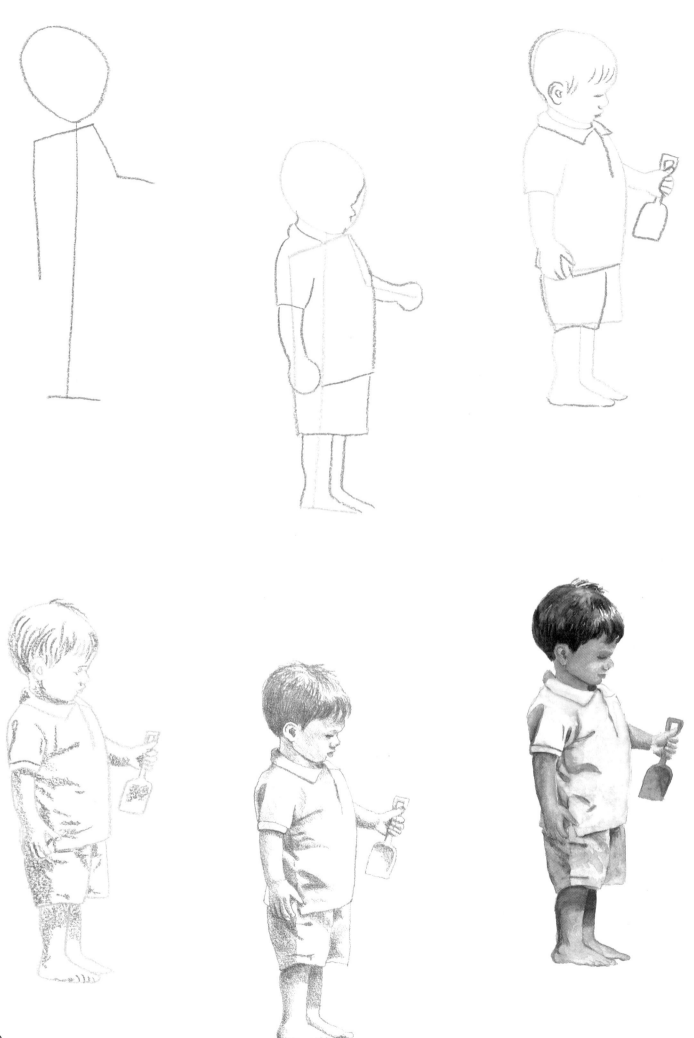

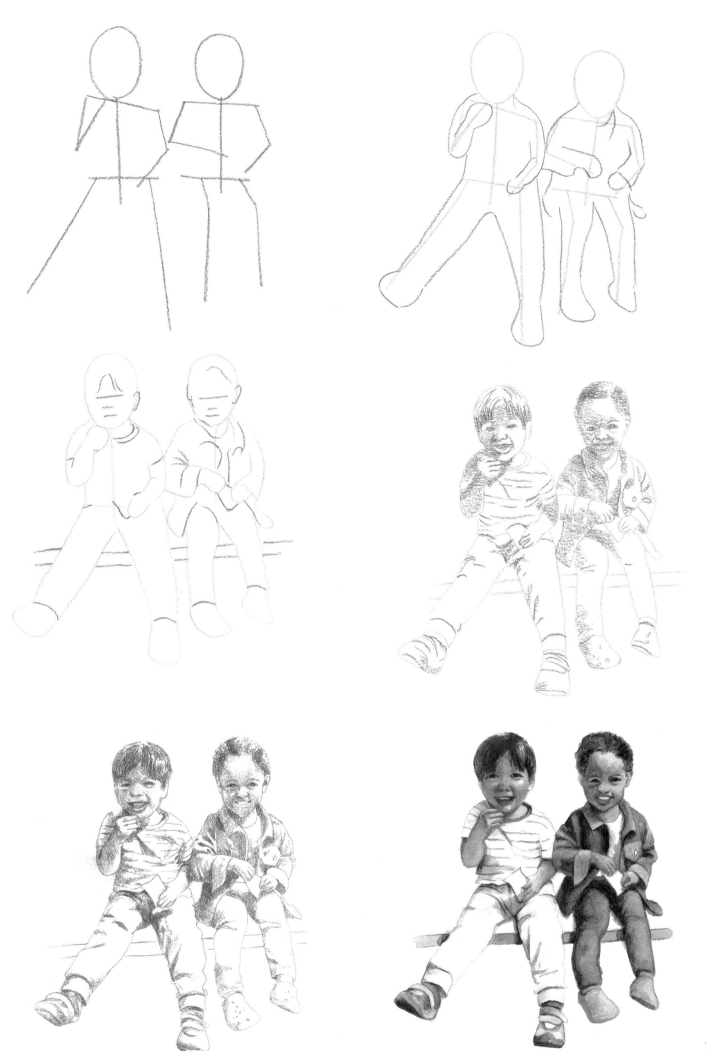

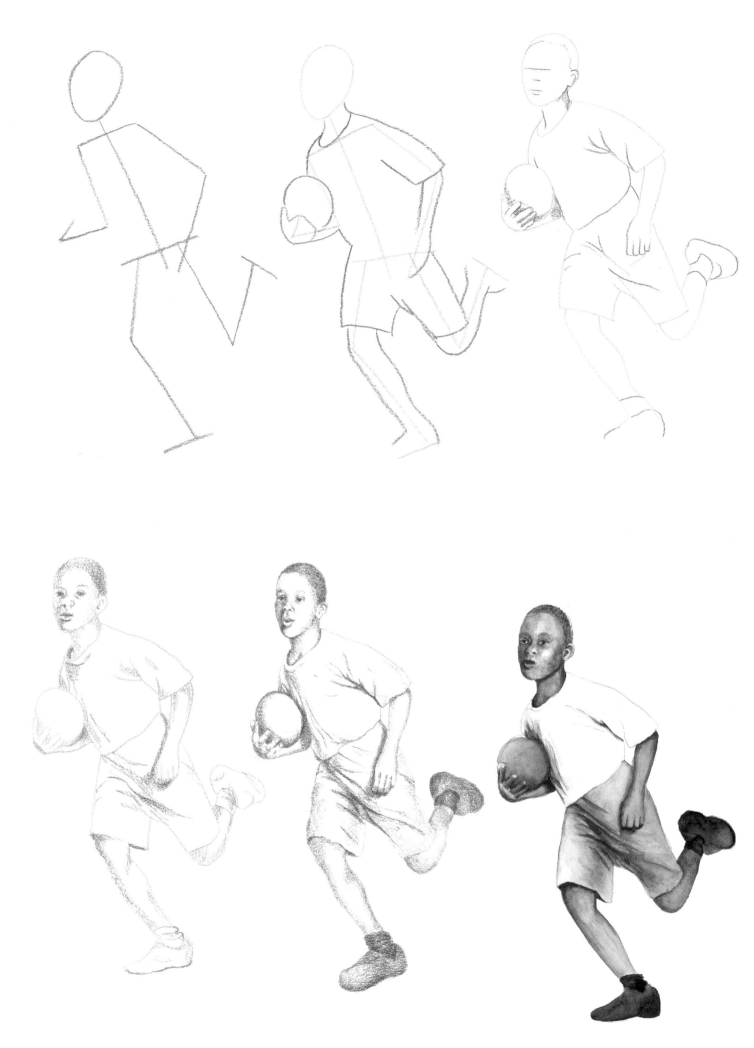

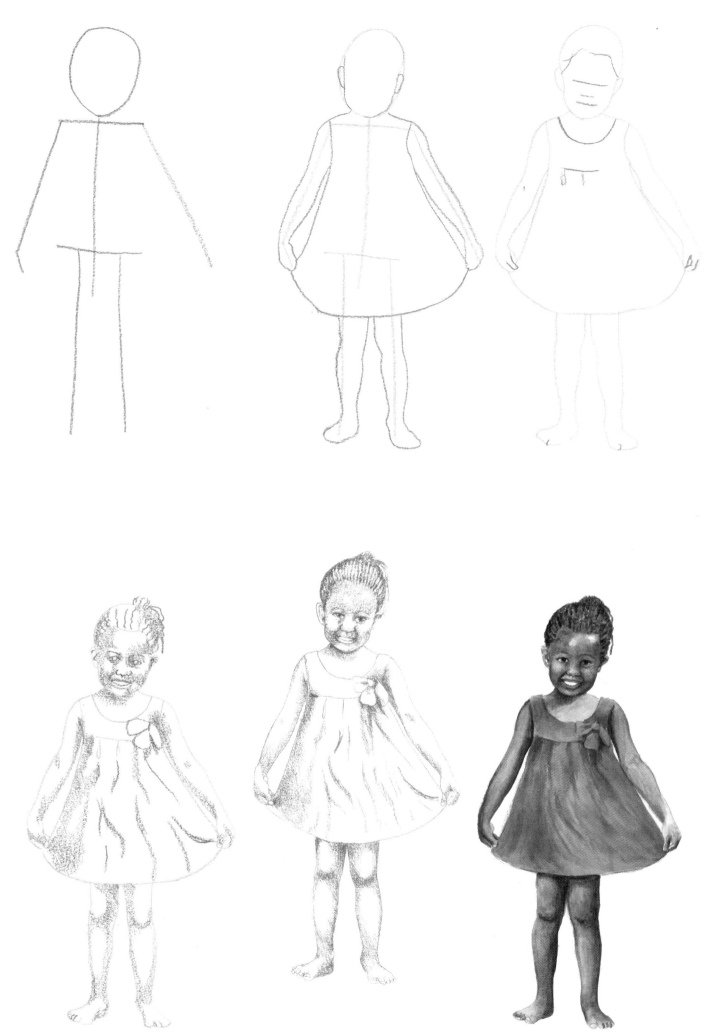

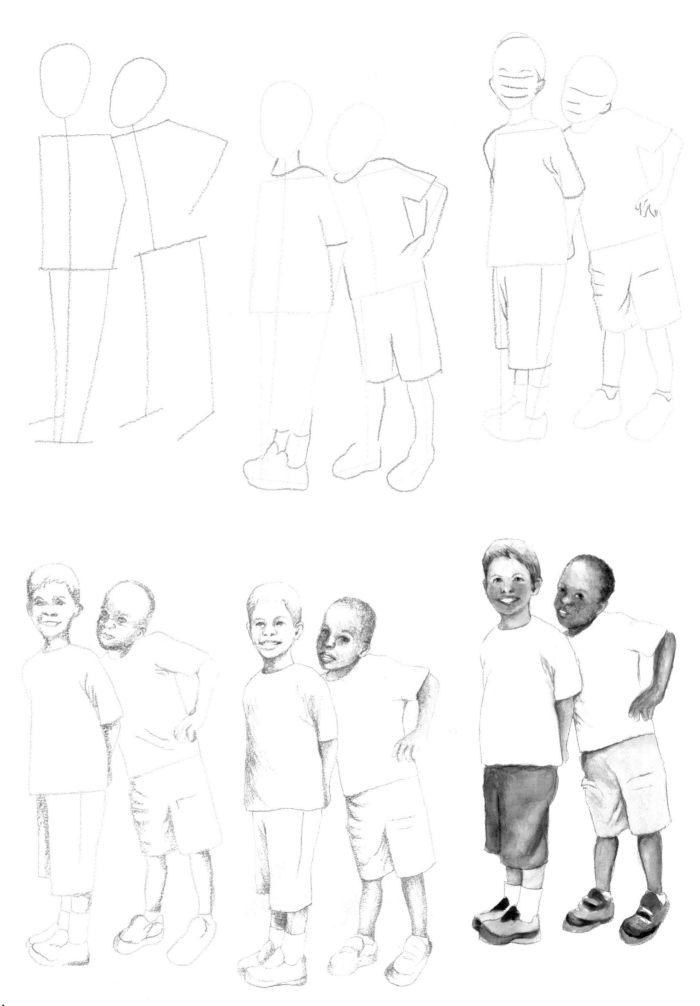

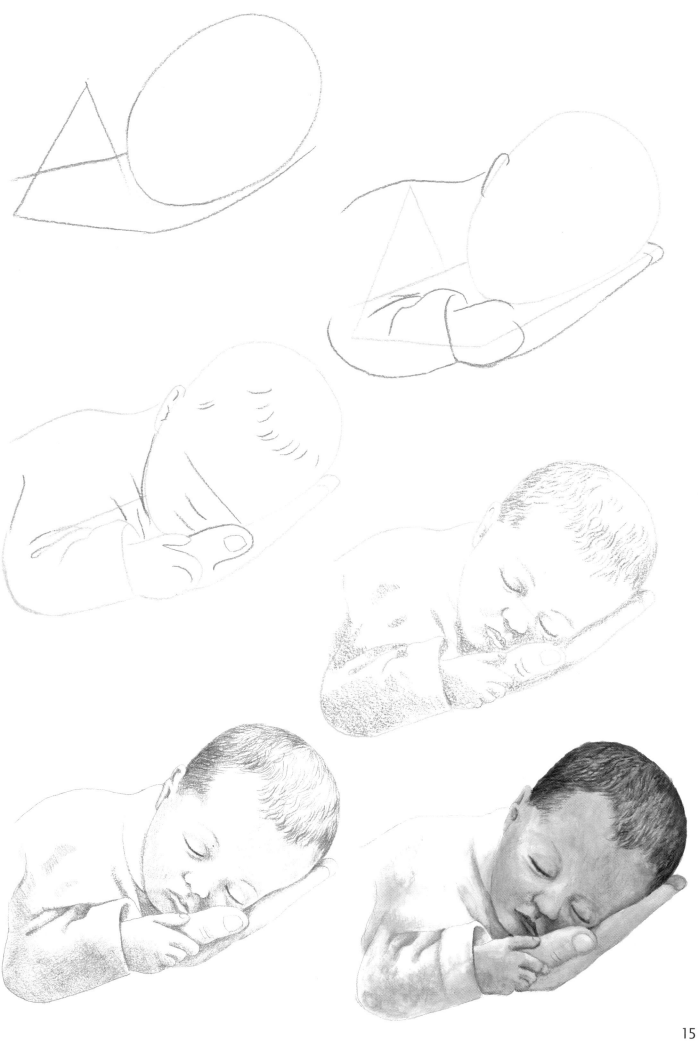

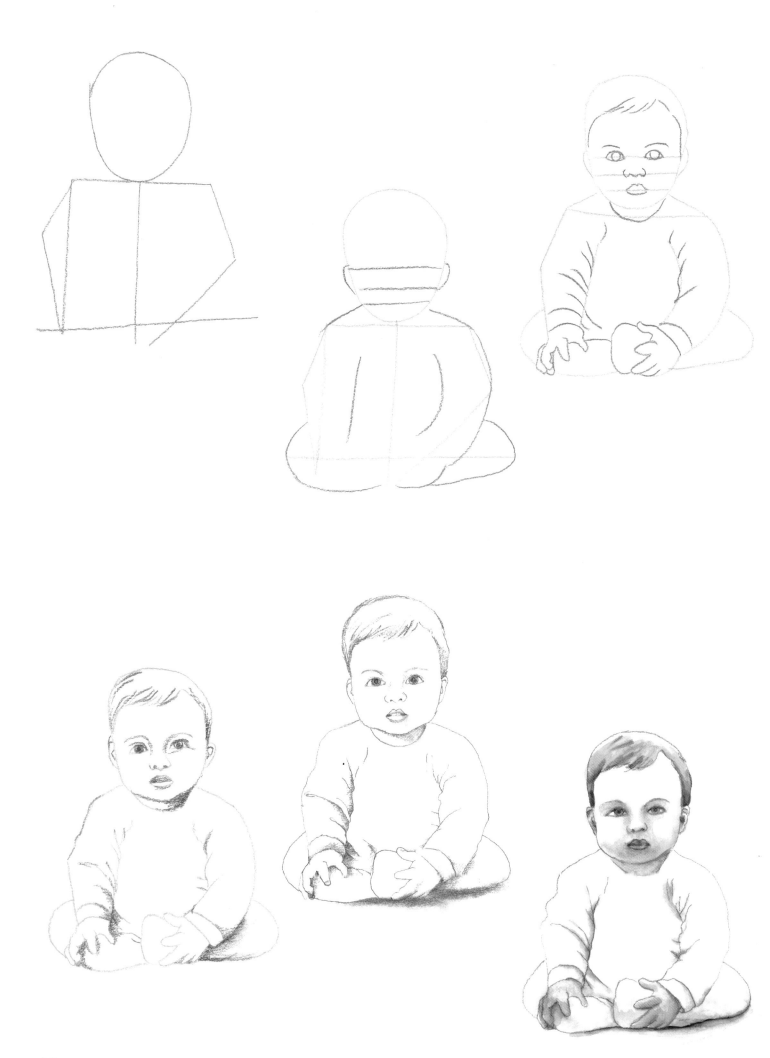

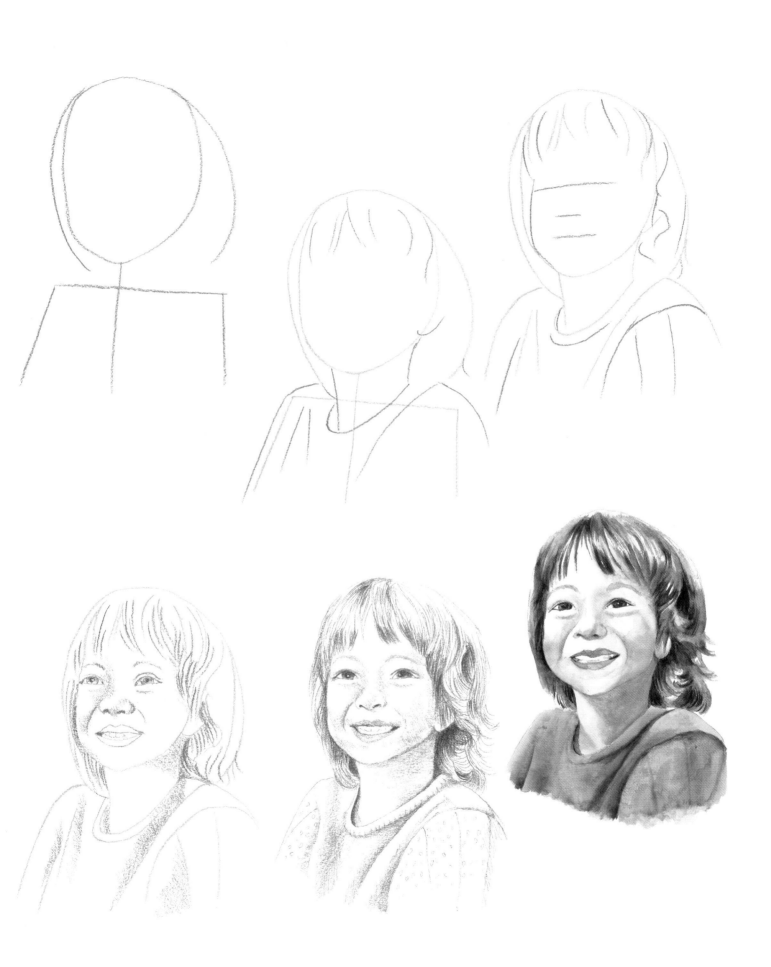

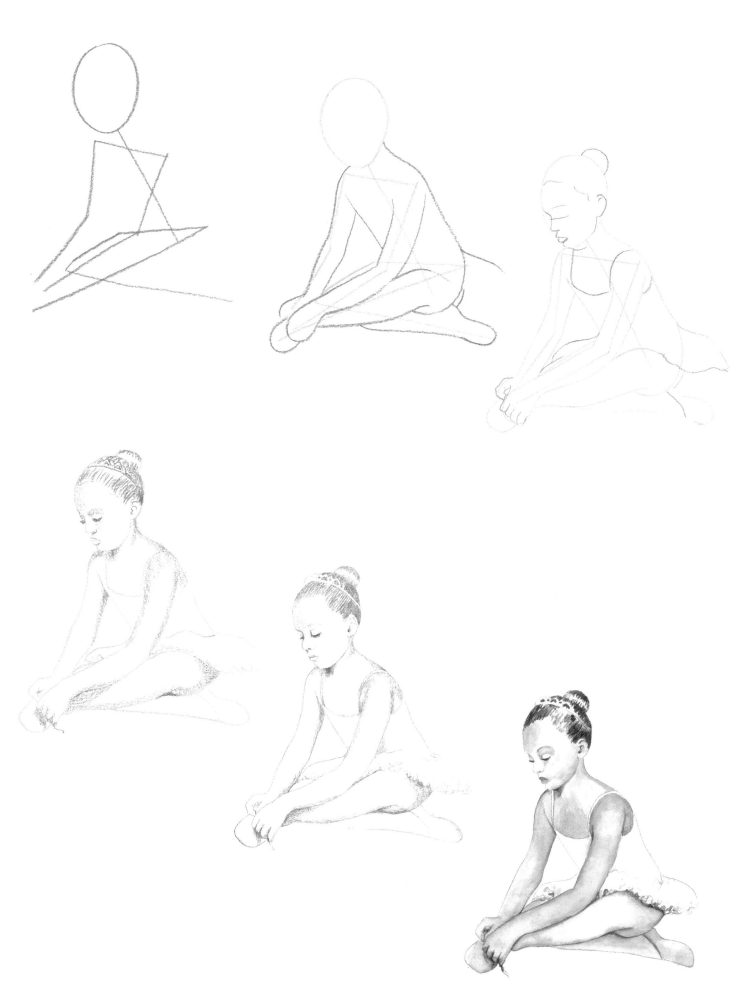

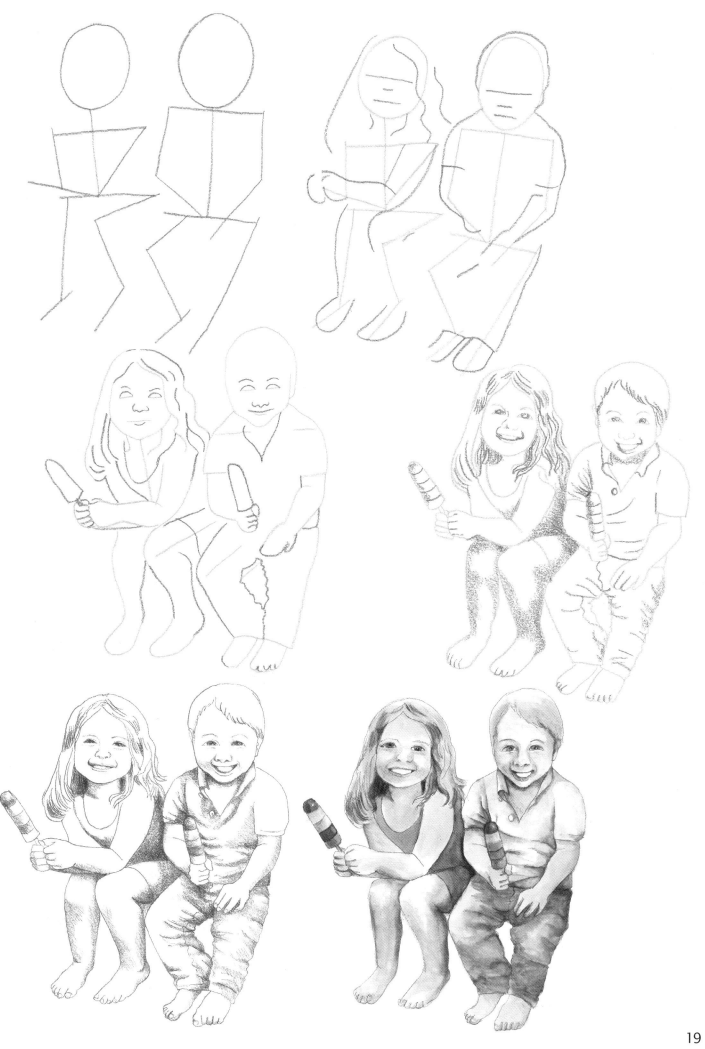

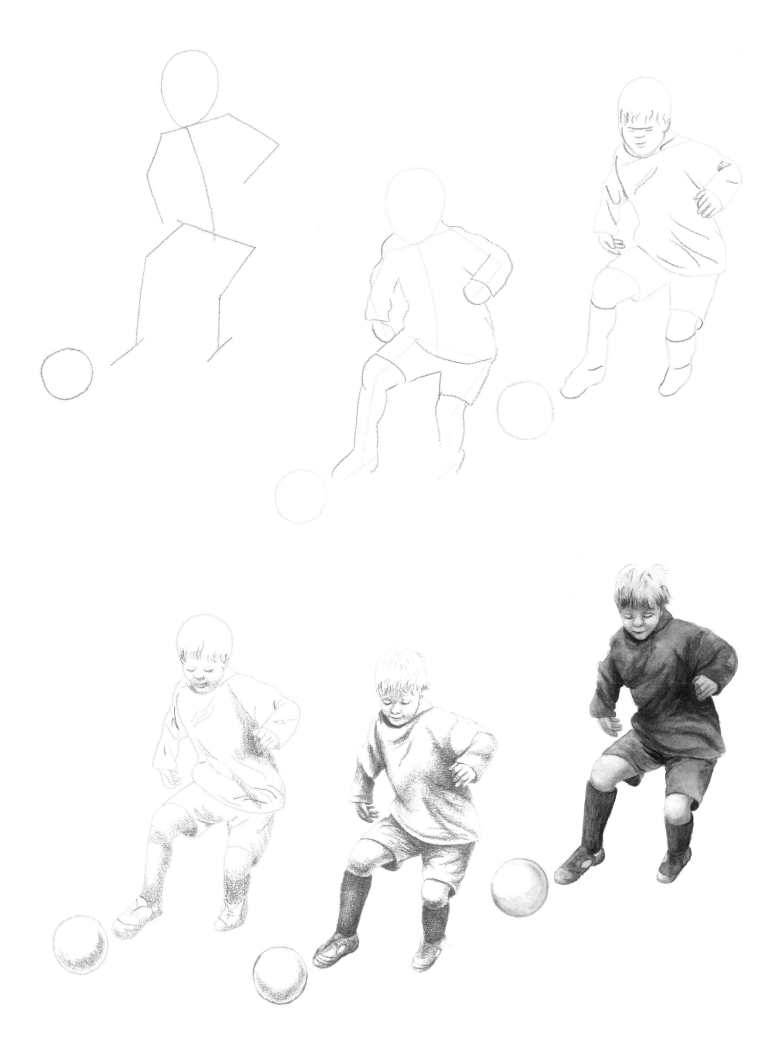

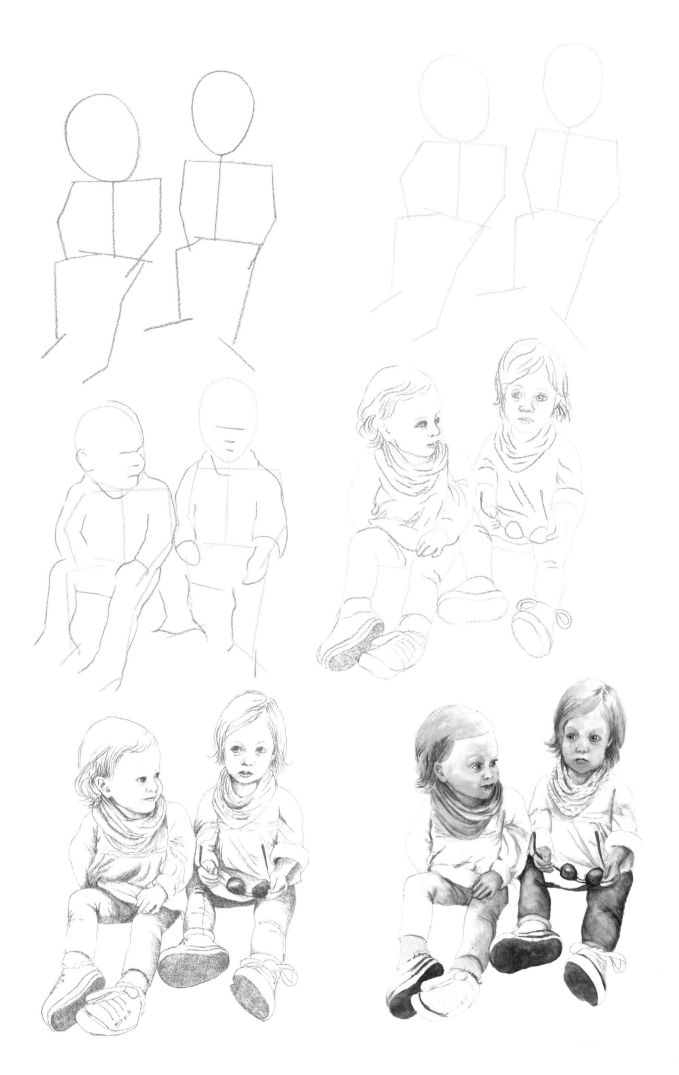

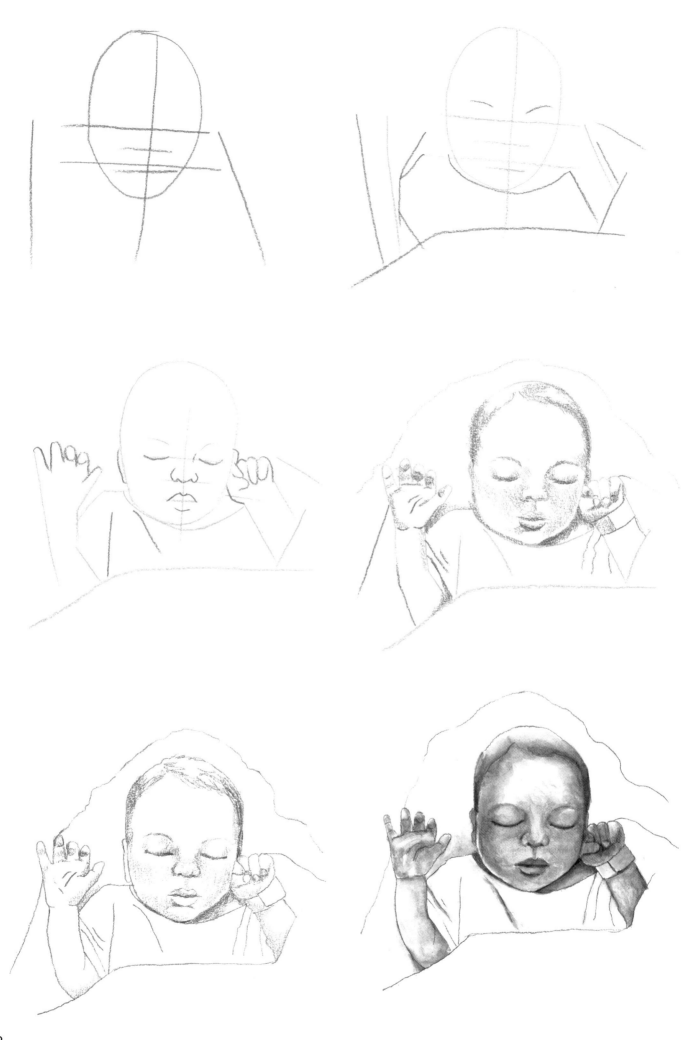

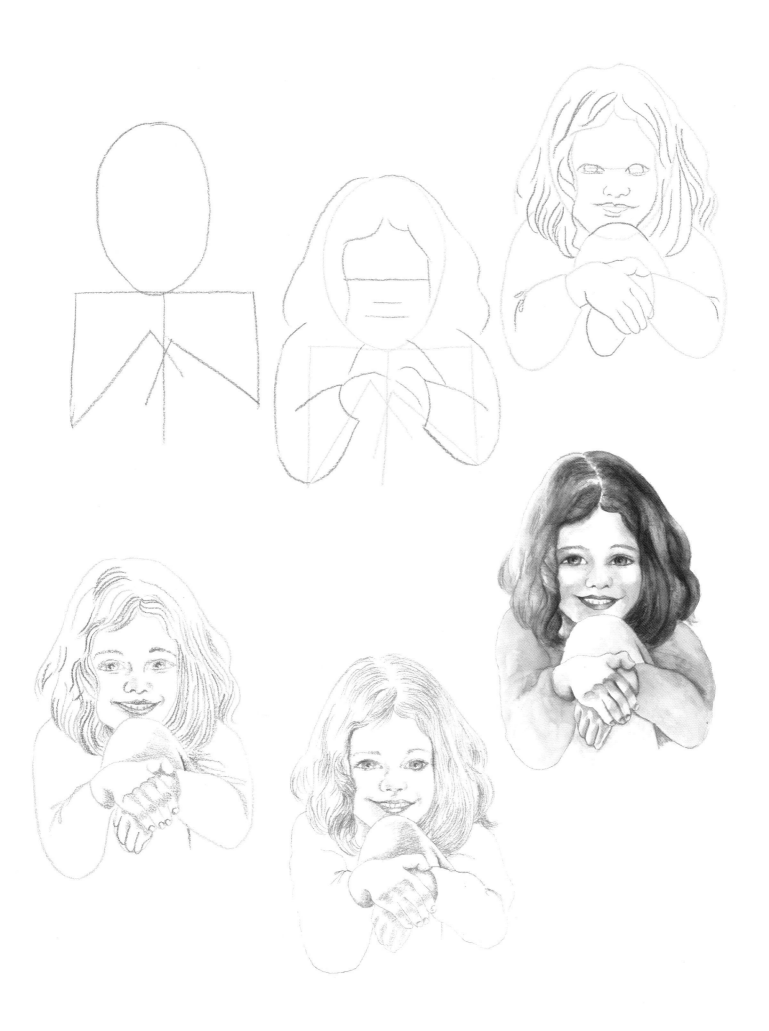

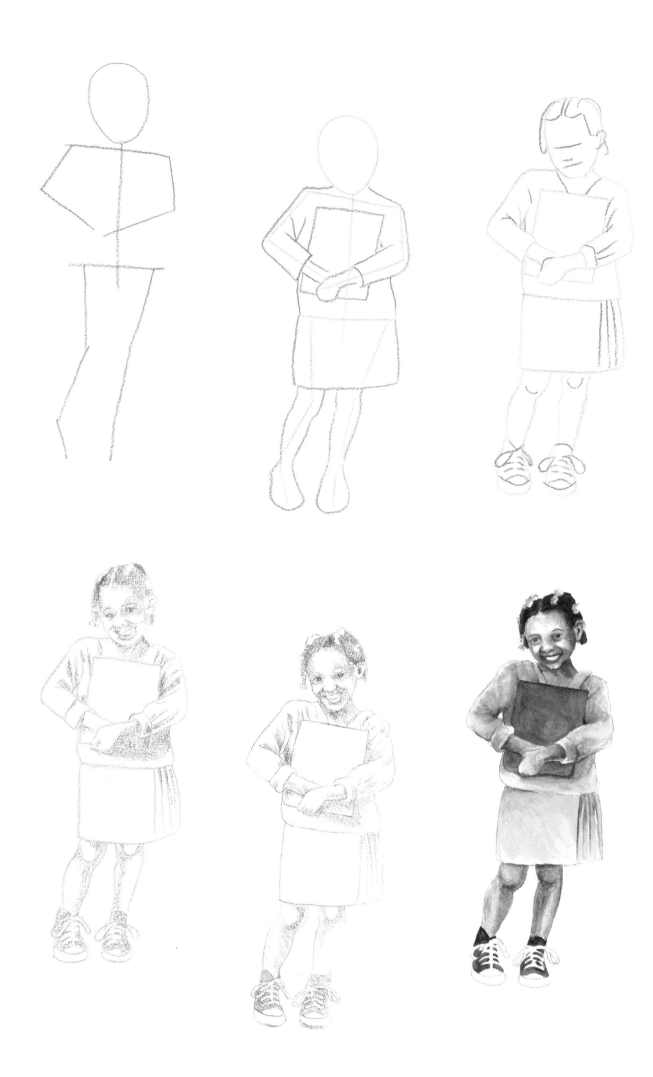

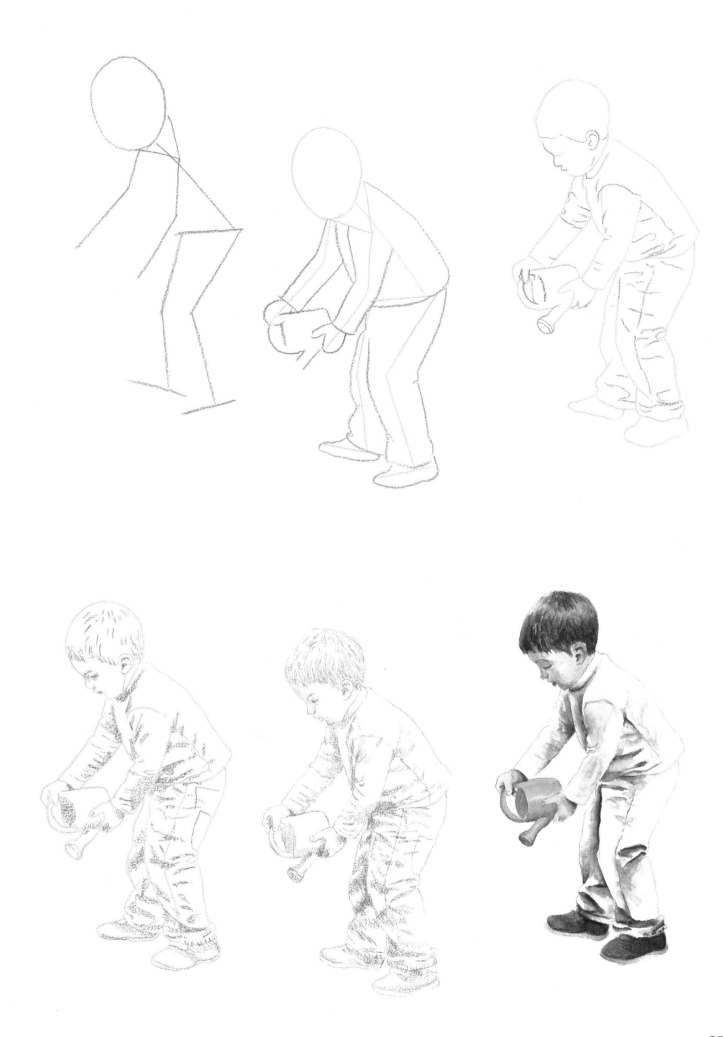

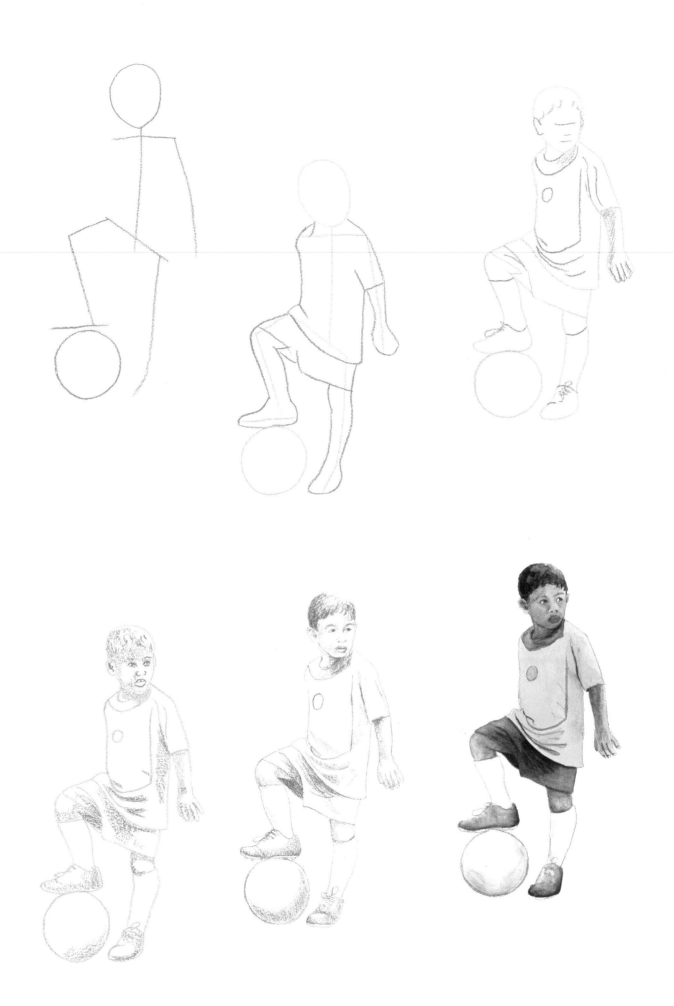

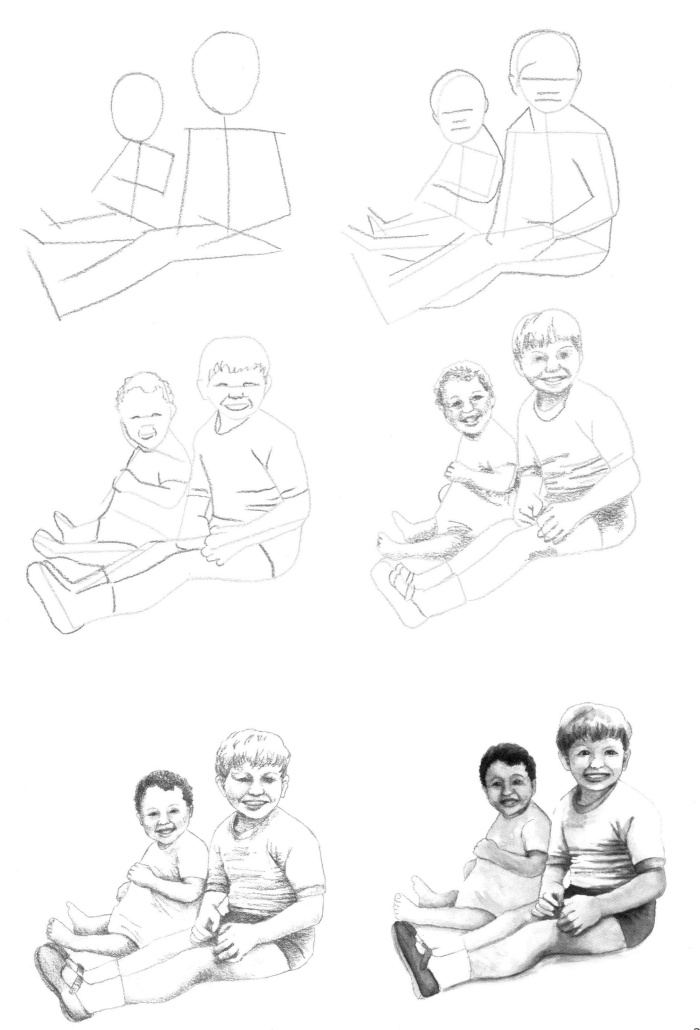

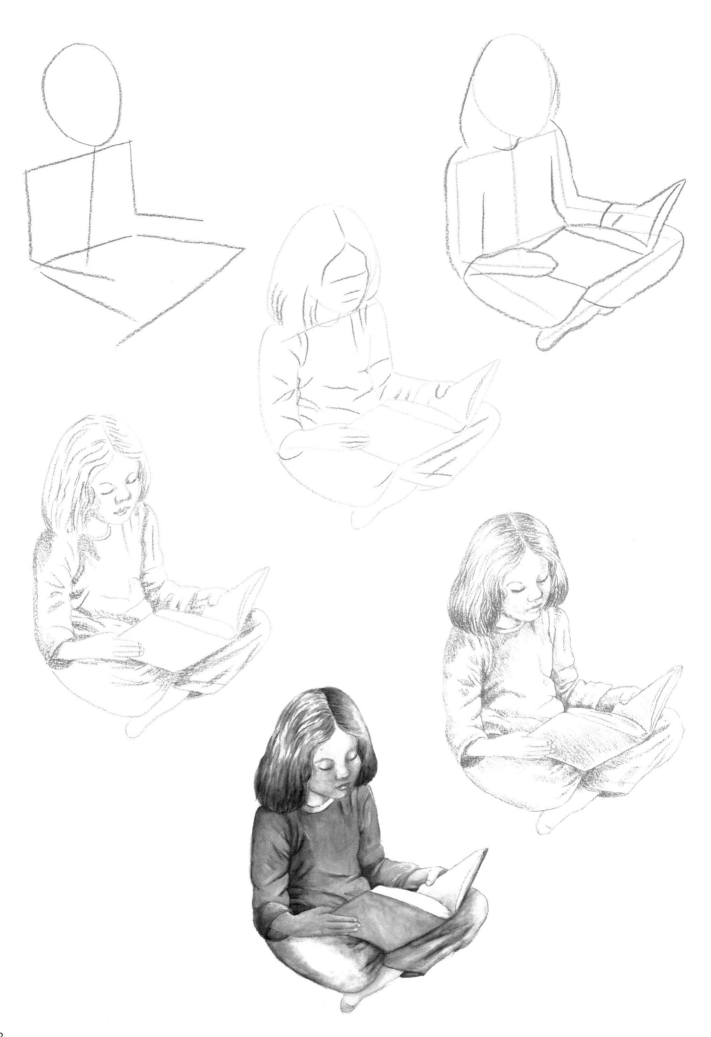

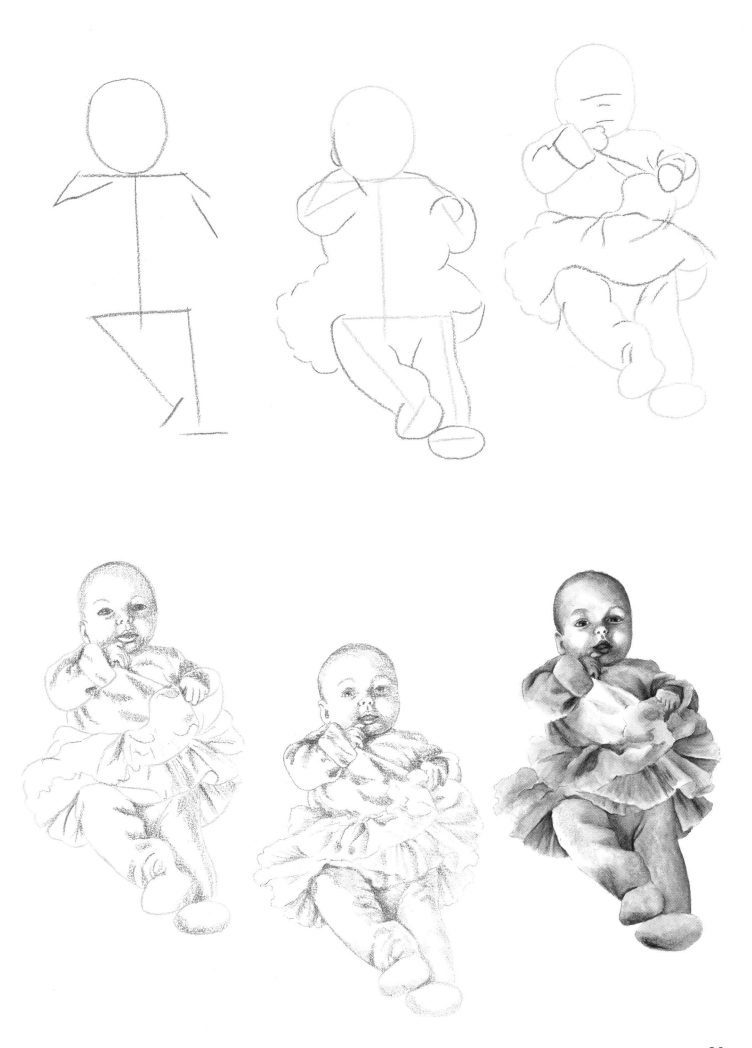

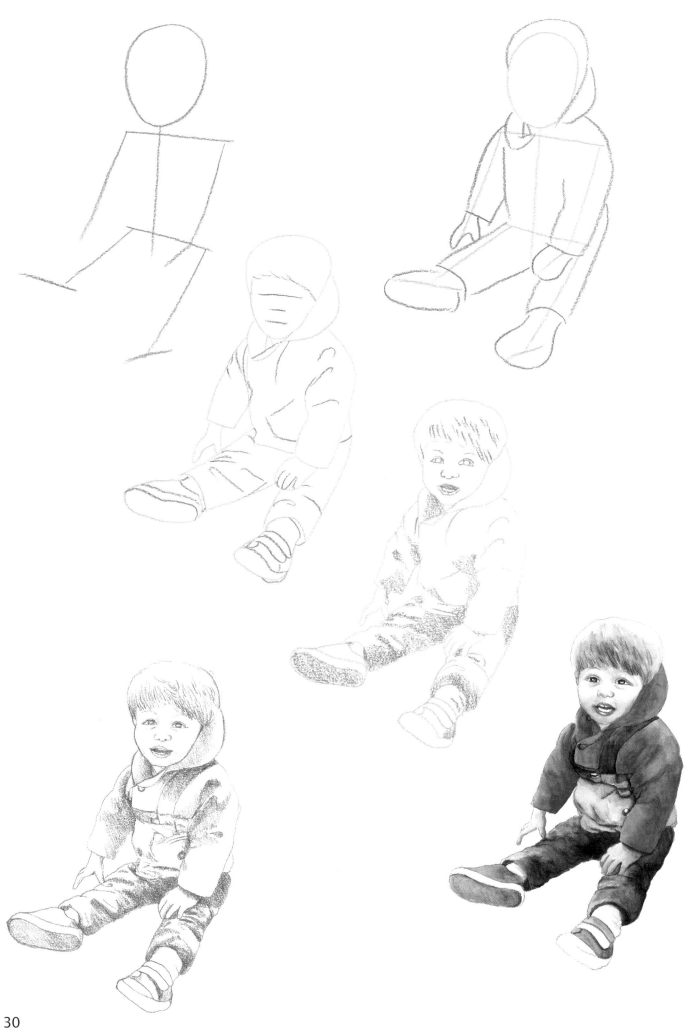

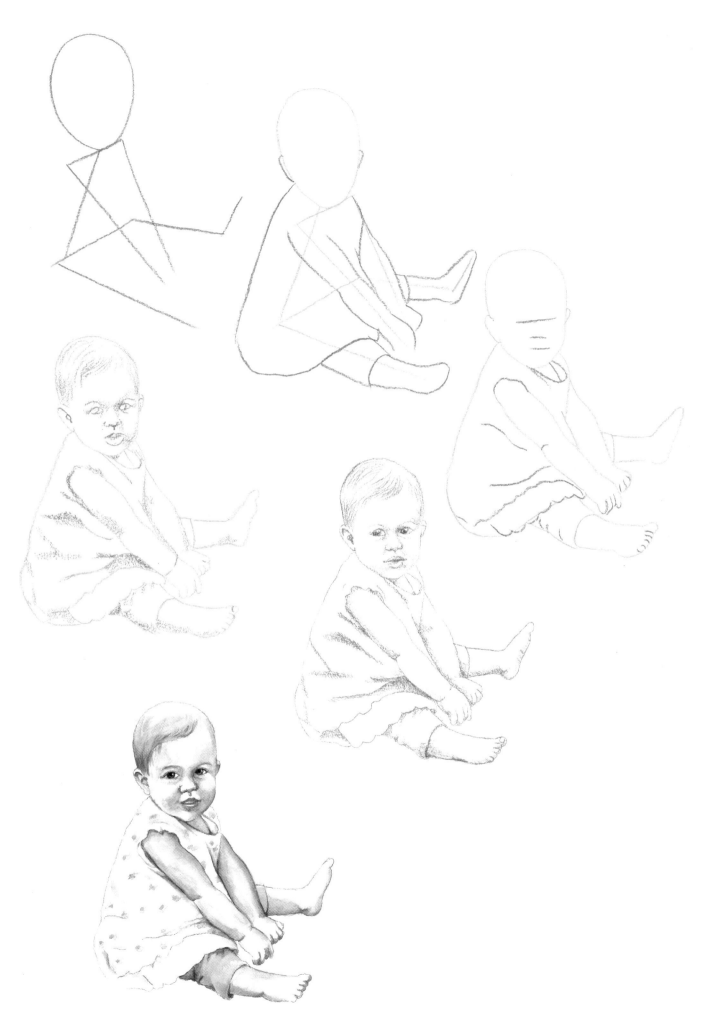

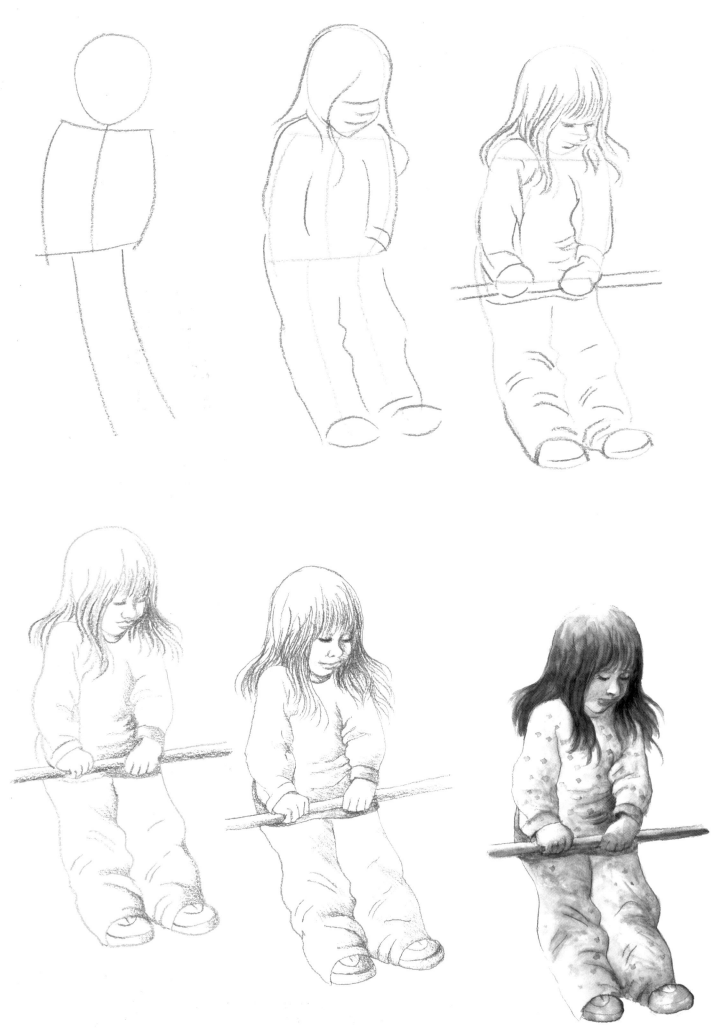